haiku

Japanese Art and Poetry

Judith Patt
Michiko Warkentyne
Barry Till

Calligraphy by
Michiko Warkentyne

Pomegranate

SAN FRANCISCO

Published by Pomegranate Communications, Inc.
19018 NE Portal Way, Portland OR 97230
800 227 1428 www.pomegranate.com

Pomegranate Europe Ltd.
Unit 1, Heathcote Business Centre, Hurlbutt Road
Warwick, Warwickshire CV34 6TD, UK
[+44] 0 1926 430111 sales@pomeurope.co.uk

Library of Congress Cataloging-in-Publication Data
Patt, Judith.
 Haiku : Japanese art and poetry / Judith Patt, Michiko Warkentyne, Barry Till ; calligraphy by Michiko Warkentyne.
 p. cm.
 Includes bibliographical references.
 ISBN 978-0-7649-5610-2 (hardcover)
 1. Haiku—Translations into English. 2. Japanese poetry—Translations into English.
 3. Prints, Japanese. 4. Haiku—History and criticism. I. Warkentyne, Michiko.
 II. Till, Barry. III. Title.

PL782.E3P38 2010
895.6'1008—dc22
 2010015645

Front cover: *Sparrow Hawk on Persimmon Branch*, c. 1930s | Nishimura Hodō (active 1930s)
Back cover: *Monkey Bridge in Kai Province*, #13 from *Famous Views of the Sixty-Odd Provinces*, 1853–1856 | Andō Hiroshige (1797–1858)

Pomegranate Catalog No. A190

Designed by Barbara Ziller-Caritey
Photography by Stephen Topfer

Printed in China
23 22 21 20 19 18 17 16 15 14 13 12 11 10 9 8 7 6 5 4

contents

introduction

Outside Japan, haiku is by far the best-known Japanese poetic form. Haiku have been written in and translated into many languages, including those as diverse as Spanish, Dutch, Greek, and Arabic. The popularity of the haiku form in all these languages is probably due as much to its brevity and seeming simplicity as to its imagery and evocative qualities. The goal of a true haiku poet is to create an emotional response in the reader through the haiku's imagery of a particular moment.

The focus of the traditional Japanese haiku is nature: the seasons, weather, and landscapes; flowers, trees, and grasses; animals and birds; and even insects, reptiles, and amphibians. Typically there is a seasonal word (*kigo*) in Japanese haiku, which might be the name of a season, a seasonal event, or an animal, plant, or natural image that carries a specific seasonal association. Some of these are snow, bamboo, and pines (for winter); plum blossoms and camellia flowers (for late winter and early spring); cherry blossoms and swallows (for spring); lotuses, irises, and various insects (for summer); and moon viewing, deer, chrysanthemums, and red maple leaves (for autumn). Natural images can have more than one connotation—for example, bamboo and pines often appear in non-winter haiku and have symbolic associations not linked with that season—and the associations of many natural images have nothing to do with the seasons—for example, crows are a symbol of loneliness, and cranes and tortoises are symbols of longevity. Haiku's focus on nature and its fleeting aspects owes much to both Shintō, the native Japanese religion rooted in nature worship, and Buddhism, which emphasizes the transitory and ephemeral qualities of our world.

THE POETIC FORM

Haiku written in English usually are composed of 17 syllables in 3 lines of 5-7-5 syllables, respectively. However, the written syllable in Japanese is slightly different from that in English. The Japanese haiku can be written with 17 sound symbols. In the Japanese syllabaries, or *kana,* there are symbols for the vowels alone, symbols for vowels in combination with consonants, and a symbol for the nasal sound

"n" when it ends a syllable. Diphthongs and long vowels are written with 2 symbols or characters, and the "n" ending a syllable is written with a separate symbol. *Kai ōi* (*The Seashell Game*) is written in kana as ka-i o-o-i—5 characters and a 5 syllable count. The first line of the haiku by Shiki on p. 62—"sanzen no"—has 3 syllables in the romaji phonetic transliteration but 5 in Japanese, with each "n" in sanzen a separate sound symbol.

If the haiku in this book were written completely in kana, it would be easy to discern the syllable count in the calligraphic versions. However, like most Japanese writing today, haiku are written in a combination of *kanji* (derived from Chinese characters) and kana. For example, *yama* (mountain) can be written either with 2 syllabic symbols, ya and ma, or with 1 kanji. In the calligraphic version of Jōsō's haiku (p. 72), the kanji form for yama is used. Haiku are unrhymed in Japanese and also generally in English translations or original haiku. The sound of a Japanese haiku is often more concise than that of a 17-syllable English translation, so some writers and translators prefer to use fewer than 17 syllables in English.

There are several problems in translating haiku from Japanese to English. In Japanese, nouns are written the same way whether they are singular or plural, so unless there is a modifier, the translator must choose which form to use. There are no punctuation marks in traditional Japanese, so the translator decides if and where to use punctuation. There are many homophones in Japanese that can lead to puns or double meanings; these are virtually impossible to translate, and their meaning can be conveyed only by long accompanying explanations. Suffix-like postposition particles (*joshi*)—such as *mo, wa, o, ya,* and *kana*—have no meaning in themselves, but they affect the word or phrase they follow. There are six categories of joshi: thematic, connective, emphatic/distinctive, adverbial, expressive, and impressive/emotional. Kana and ya are used frequently in the haiku in this book to add an emotional tone. Kana often marks the end of a haiku and emphasizes the image or mood—in some cases as if there is an

"Ah!" reaction. In use, these postpositions can sometimes belong to more than one category, so the interpretation of a haiku can be subtle and subjective. For example, the first line of Bashō's famous frog haiku (p. 42) is "furu ike ya." Furu ike means old pond; ya is a joshi of the emphatic/distinctive category in this case. Bashō is pointing at a certain pond and saying, "behold the old pond," but also with the feeling of being impressed and moved, as the sound of an insignificant frog jumping into the water awakens the old, still, and serene pond.

Many haiku also make reference to historical events or cultural practices that are understood by Japanese readers or people well versed in Japanese culture, but which elude the general reader. For instance, Bashō's frog haiku has been interpreted as an impression of the Zen Buddhist practice of meditation, with the silent pond representing meditation and the splash symbolizing the shout of the teacher that evokes the moment of enlightenment in the startled student. The Japanese poets represented in this book were extremely well versed in the great poetry traditions of Japan and often made reference to earlier works in their own compositions. For example, the haiku about chrysanthemums by Shiki (p. 56) was composed in response to a famous poem by Ransetsu written 200 years earlier (see Henderson, p. 160).

EVOLUTION OF HAIKU

Haiku grew out of the classical court poetry of the Heian and Kamakura periods (eighth–fourteenth centuries); the *tanka* or *waka* poem was unrhymed and consisted of 5 lines or phrases in a 5-7-5-7-7–syllable pattern. During the Muromachi period (1336–1573), a group poetry collaboration known as *renga* became very popular. One poet would compose the first 3 lines, another poet the last 2, but then a third poet would compose 3 lines that formed a new poem with the previous 2. This could go on and on, with subjects, seasons, and themes constantly changing. Renga became a social occasion,

with the quality of the poetry sometimes diluted by the quantity of alcohol consumed. The earliest renga were composed by members of the elite classes, and their standard length was 100 stanzas, but in the sixteenth century, a shorter 36-verse format developed, which was patronized by poets of the merchant and farmer classes. This shorter, more colloquial form was called *kasen,* and the style was known as *haikai [playful] no renga.* The first 5-7-5 verse was often composed by a poet who was the leader of a poetry club or school, and it became an independent poetry form in itself. This first verse was known as a *hokku* until the late nineteenth century, when Masaoka Shiki (1867–1902) introduced the term *haiku* for it. We will use the modern term haiku for the poems of Bashō and others discussed here, even though they knew their poems as hokku.

THE LINEAGE OF HAIKU MASTERS

Matsuo Bashō (1644–1694), Taniguchi Buson (1715–1783), and Kobayashi Issa (1763–1828) are considered the three greatest haiku poets. They all lived during the Edo or Tokugawa period (1603–1868). Following 150 years of conflict and civil war, the Edo period was a time of peace and political stability under the control of the Tokugawa clan. The development of the arts was fostered, education was widespread, literacy increased greatly, and publishers producing woodblock print books, pictures, and broadsheets abounded. Kyoto remained the seat of the emperor and the center of traditional aristocratic culture. The city of Edo (now Tokyo), location of the shogun's castle and center of government, had an estimated population of 1.2 million by the early 1700s. A vibrant new middle-class culture developed in Edo; many of its members were patrons or students of haikai no renga and haiku as well as *kabuki* and *ukiyo-e.* Bashō, Buson, and Issa all traveled to Edo to study poetry.

Matsuo Kinsaku (better known as Bashō) was born into a low-ranking samurai family in Ueno, some thirty miles southwest of Kyoto. As a boy, he became an attendant to a member of the samurai

clan ruling the area. The boy and his master shared an interest in poetry, and both had published a few poems when Bashō's master died suddenly in 1666. Bashō resigned his position and went to Kyoto, where more of his poems were published and he edited his first anthology, *The Seashell Game* (*Kai ōi*), a collection of poems composed by about thirty poets at a haikai contest Bashō organized and critiqued.

In 1672 Bashō went to Edo, where he continued his poetry studies and may have held a minor government post briefly. Bashō started his own poetry school in 1674, and by the 1680s he had many students. They gave him a cottage on the outskirts of Edo with a banana tree (*bashō*) planted in the garden. The cottage became known as the Bashō-an, and the poet changed his poetic name to Bashō. He published more anthologies, including *Frog Verses* (*Kawazu awase*), which contained only haiku with references to frogs—among them Bashō's famous frog haiku. He also published his first travel records in *haibun* form, in which haiku are incorporated within prose. The fifth Bashō school poetry collection, *Monkey's Straw Raincoat* (*Sarumino*), published in 1691, is considered Bashō's most representative and influential work. In 1694 Bashō and his companion, Sora, took a journey to northern Honshu, which is chronicled in his most famous travel diary, *Journey to the Far North* (*Oku no hosomichi*). Bashō died in Osaka at the age of fifty while on another of his trips. Three hundred of his students attended his funeral and burial on the shore of Lake Biwa.

This book contains haiku by a number of Bashō's students, including Ransetsu, Shikō, Kikaku, Hokushi, and Jōsō. Bashō's contribution to haiku is seen as bringing poetic insight and emotion to the commonplace, using simple language, and often using two independent elements that, when juxtaposed, create a more powerful image—for example, the serene pond and the lively frog. In this and many other poems, Bashō illustrated the beauty of things not generally considered beautiful, a poetic practice continued by many of his followers.

Taniguchi Buson, known as a painter under the name Yosa Buson, was the son of a well-to-do farmer from a village on the outskirts of Osaka. When he was about twenty, Buson went to Edo to study poetry and painting. There he joined a circle of Japanese scholars interested in studying Chinese poetry and painting. The Japanese Nanga (or Bunjinga) painting school was influenced by later Chinese paintings, and today Buson is considered one of the three best painters of the Nanga school. Buson supported himself throughout his life as a painter, bringing a poetic Japanese sensibility about weather and seasons to many of his paintings. As a poet, he followed the Bashō school and he worked to revive its popularity. Later, when one of Buson's students asked him if there was a secret to writing haiku, Buson told him it was to use the commonplace to escape the commonplace.

When Buson was twenty-six, he left Edo for ten years to travel and paint in northern Japan and retrace Bashō's journeys. Buson later created paintings related to Bashō's famous work *Journey to the Far North,* in both screen and scroll formats, in a style similar to the simplified, almost cartoon-like *haiga*—a combination of poetry, calligraphy, and painting that Buson and other painters and poets produced as very personal records. Buson went to Kyoto in 1751 and, with the exception of three years on the seacoast, spent the rest of his life there. He enjoyed the cultural life of Kyoto, married Tomo—who was a poet herself—and by his fifties was the leader of the Kyoto poets. His last poem described the plum blossoms in his garden turning white in the early morning light.

Kobayashi Issa was a farmer's son from a small mountain village in central Japan. He was extremely prolific and is the most beloved of the three major haiku poets. Bashō wrote about 1,000 haiku, Buson about 3,000, and Issa some 20,000. Issa's life was one of both poverty and pain. His mother died when he was two, and his stepmother was stereotypically hateful. At fourteen, Issa was sent to Edo, where he eventually gained some success as a poet in a vernacular school of haiku. At age twenty-nine, Issa set out on ten years of travels, including a visit to Bashō's tomb; he acted as a haikai master along the

way and wrote travel journals on his return to Edo. In 1801 his father died, and there were years of legal wrangling over the estate. Issa finally returned to his mountain village, at age fifty-one married a local girl, Kiku, and settled at last into a happy life. However, none of their four children survived past one year, and Kiku died with the fourth delivery. Issa married twice more but was survived by only one daughter—born after he died—and thousands of poems cherished by haiku lovers. Many of Issa's haiku were about humble things, including insects—ants, flies, fleas, and mosquitoes.

PREPARATION OF THIS BOOK

The Art Gallery of Greater Victoria has one of the best collections of Japanese art in Canada; it is particularly strong in the areas of eighteenth- through twentieth-century woodblock prints and Nanga school paintings. A selection has been made of eighteenth- and nineteenth-century paintings, nine-teenth-century *ukiyo-e,* and twentieth-century *shin hanga* prints from the gallery collection to comple-ment the haiku in this book. The haiku are presented in Japanese calligraphy, romaji transliteration, and English translation. Every effort has been made to keep the English translations as literal as possible—a choice that may not always do justice to the poetic quality of the original poem but does not distort the poem beyond recognition. In-depth studies of haiku, such as those listed in the Selected Bibliography, present alternate translations as well as discussion of context and nuance. Most of the haiku are in classical Japanese language (*bungo*) rather than contemporary spoken Japanese (*kōgo*). Japanese script is written right to left, top to bottom, and that is the way the calligraphic versions of the haiku in this book are written, while the romaji transliterations are given in English left-to-right reading. The book is organized by seasons—spring, summer, autumn, winter—as are traditional Japanese haiku anthologies.

selected bibliography

Bashō, Matsuo. *Bashō's Narrow Road: Spring and Autumn Passages.* Translated and
 annotated by Hiroaki Sato. Berkeley, CA: Stone Bridge Press, 1996.

Blyth, R. H. *Haiku.* 4 vols. Tokyo: Hokuseido Press, 1949–1952.

————. *A History of Haiku.* 2 vols. Tokyo: Hokuseido Press, 1963–1964.

Hass, Robert, ed. and trans. *The Essential Haiku: Versions of Bashō, Buson, and Issa.*
 Hopewell, NJ: The Ecco Press, 1994.

Henderson, Harold G., ed. and trans. *An Introduction to Haiku: An Anthology of Poems
 and Poets from Bashō to Shiki.* Garden City, NY: Doubleday, 1958.

Higginson, William J., with Penny Harter. *The Haiku Handbook.* Tokyo: Kodansha
 International, 1989.

Mason, Penelope. *History of Japanese Art.* New York: Harry N. Abrams, Inc., 1993.

Sato, Hiroaki. *One Hundred Frogs: From Renga to Haiku to English.* New York:
 Weatherhill, 1983.

 spring

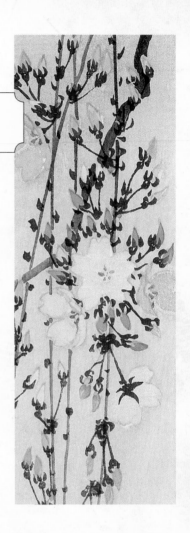

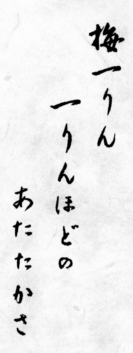

ume ichi rin
ichi rin hodo no
atatakasa

As on the plum comes
blossom after blossom, so
comes the warmth of spring.

—Ransetsu (1653–1708)

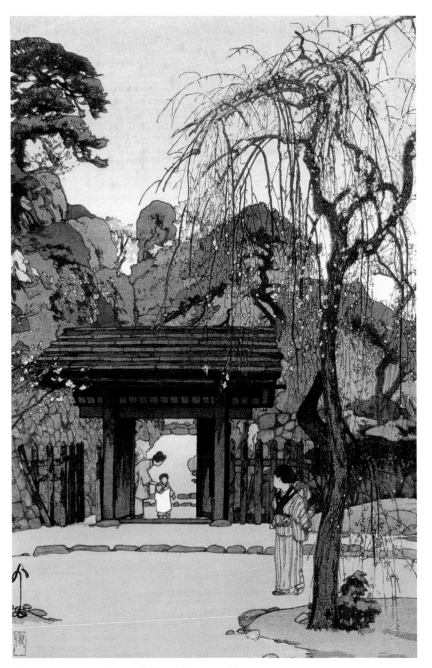

Plum Gateway, 1935 | Yoshida Hiroshi (1876–1950)
Woodcut on paper | Gift of Elizabeth Marsters | AGGV SC802

目はよこに
鼻はたてなり
春の花

me wa yoko ni
hana wa tate nari
haru no hana

Eyes, back and forth,
nose, up and down—
the flowers of spring!

—Onitsura (1660–1738)

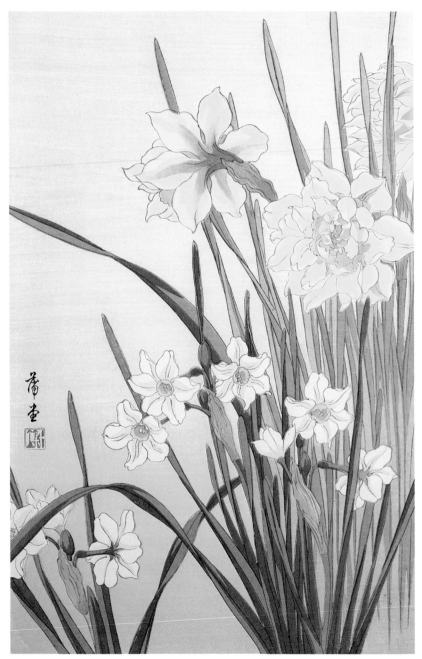

Narcissus, c. 1930s | Nishimura Hodō (active 1930s)
Woodcut on paper | Senora Ryan Estate | AGGV 1991.052.005

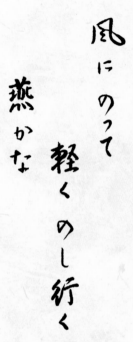

風にのって
軽くのし行く
燕かな

kaze ni notte
karuku noshiyuku
tsubame kana

Gliding on the wind,
lightly soaring in the sky—
the swallow's flight.

—Sōseki (1867–1916)

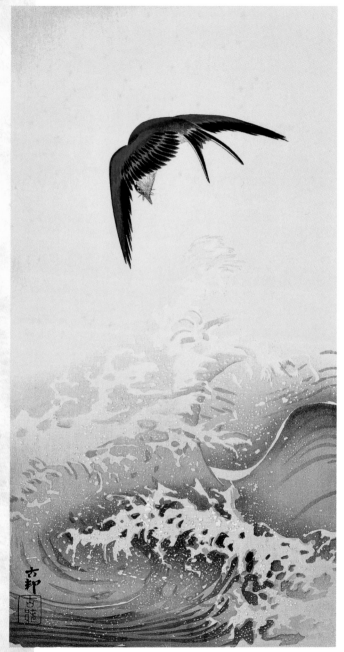

Swallow over the Ocean Wave, early 20th century
Ohara Koson (Shōson) (1877–1945)
Woodcut on paper | Gift of Robin Bassett | AGGV 2008.028.003

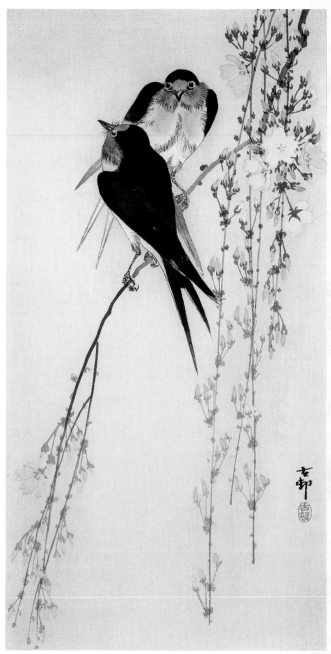

さ
ま
ざ
ま
の
も
の
思
い
出
す
桜
か
な

sama zama no
mono omoidasu
sakura kana

So many things
they call into my thoughts—
cherry blossoms!

—Bashō (1644–1694)

Swallows and Hanging Cherry Blossoms, early 20th century
Ohara Koson (Shōson) (1877–1945)
Woodcut on paper | Gift of Mr. and Mrs. William Hepler | AGGV 1992.044.003

春の海
ひねもす
のたり
のたりかな

*haru no umi
hinemosu notari
notari kana*

The springtime sea
all day long goes gently
up and down, up and down.

—Buson (1715–1783)

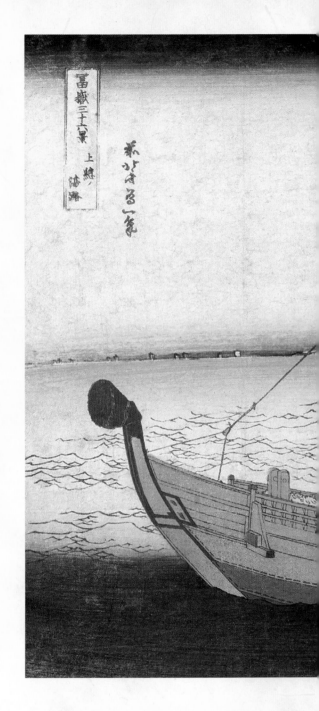

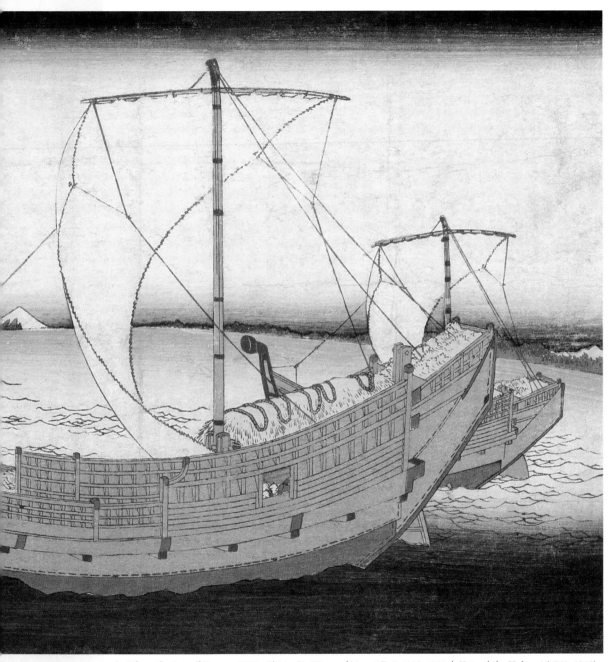

Fuji from the Sea off Kazusa, #30 in *Thirty-Six Views of Mount Fuji*, 1830–1833 | Katsushika Hokusai (1760–1849)
Woodcut on paper | Fred and Isabel Pollard Collection | AGGV 1963.078.001

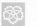

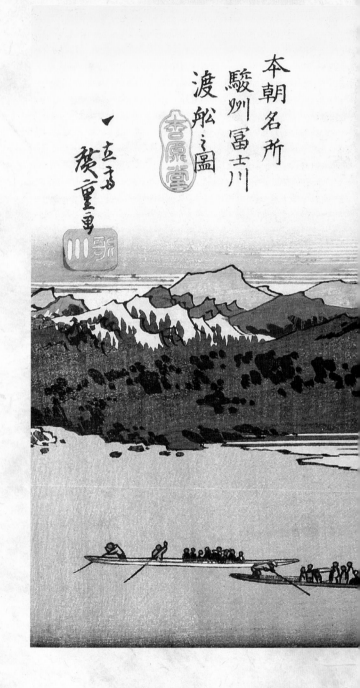

山路きて
何やらゆかし
すみれ草

yama ji kite
naniyara yukashi
sumire gusa

Beside the mountain path,
somehow so appealing,
violets in bloom.

—Bashō (1644–1694)

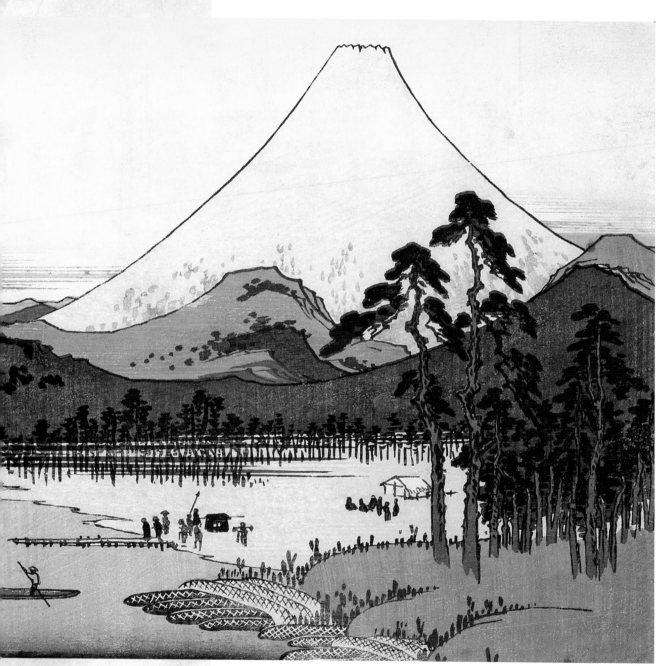

Fujikawa River, Ferry Boats, from *Famous Places in Japan,* c. 1840 | Andō Hiroshige (1797–1858)
Woodcut on paper | Gift of Theodore Lande | AGGV 1984.054.020

*taka no me mo
ima ya kure nu to
naku uzura*

When the dusk sets in
and hawks can no longer see—
the quail cry loudly.

—Bashō (1644–1694)

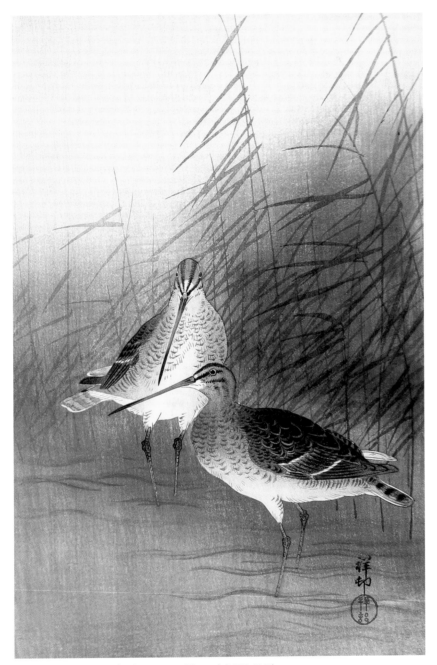

Birds and Reeds, 1926 | Ohara Koson (Shōson) (1877–1945)
Woodcut on paper | Gift of Theodore Lande | AGGV 1984.054.008

*hana chirite
ko no ma no tera to
nari ni keri*

Cherry blooms are falling—
and now between the trees,
a temple appears.

—Buson (1715–1783)

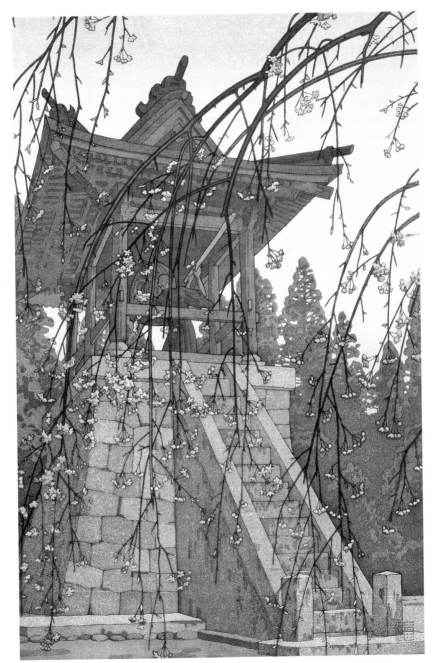

Heirinji, Temple Bell, 1951 | Yoshida Toshi (1911–1995)
Woodcut on paper | Gift of Betty Demic | AGGV 1999.028.001

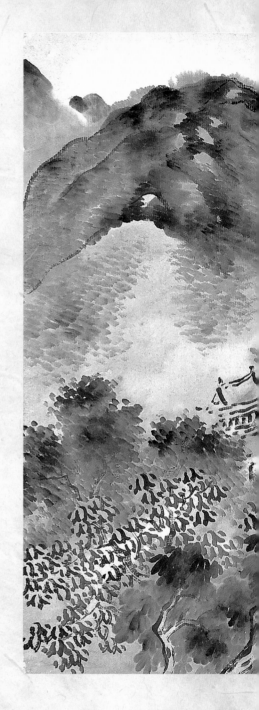

めずらしと
見るものごとに
春や行く

mezurashi to
miru mono goto ni
haru ya yuku

How wonderful
each thing that I look at—and
springtime goes away.

—Kitō (1740–1788)

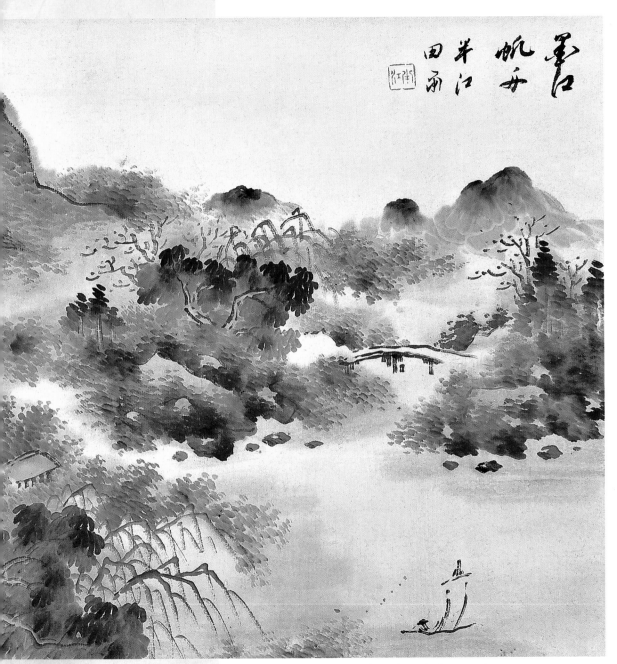

墨帆舟
白半江
　雨田

Sailboat on an Inky River, n.d. | Okada Hankō (1782–1846)
Ink on paper | Gift of Mr. and Mrs. R. W. Finlayson | AGGV 1978.266.001

 summer

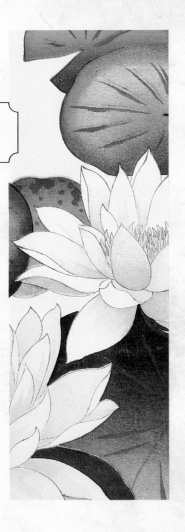

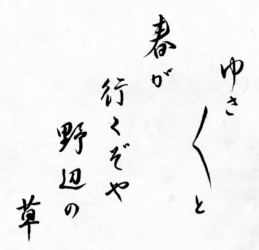

yusa yusa to
haru ga yuku zo ya
nobe no kusa

Swaying, swaying,
as springtime goes away—look—
in the fields, the grasses!

—Issa (1763–1828)

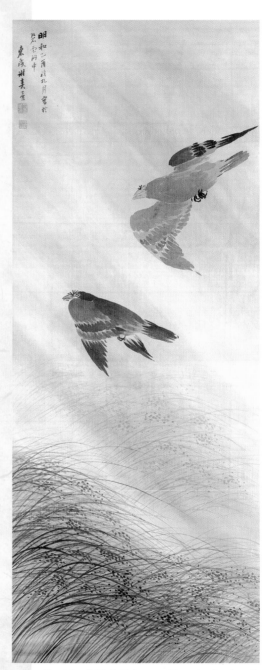

Two Mynah Birds Flying over Flowering Reeds, n.d.
Yosa Buson (1715–1783) | Ink on silk
Gift of Mrs. R. W. Finlayson | AGGV 1982.074.001

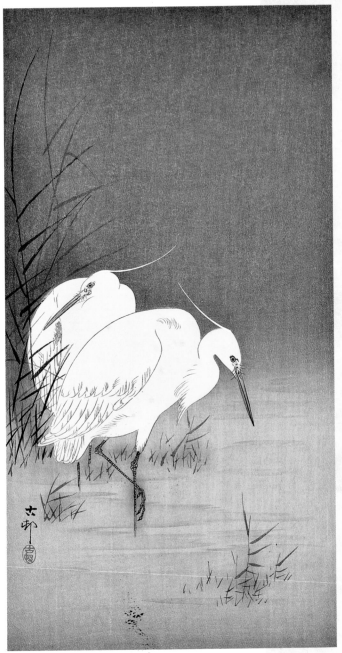

Two Egrets at Night, c. 1910
Ohara Koson (Shōson) (1877–1945) | Woodcut on paper
Gift of Robin Bassett | AGGV 2008.028.002

いなずまや
闇の方行く
五位の声

inazuma ya
yami no kata yuku
goi no koe

The glare of lightning—
and through the darkness echoes
the night heron's cry.

—Bashō (1644–1694)

梅雨明けて
初めて咲いた
池の蓮

tsuyu akete
hajimete saita
ike no hasu

Rainy season ends—
water lilies in the pond
suddenly open.

—Sasabune (contemporary)

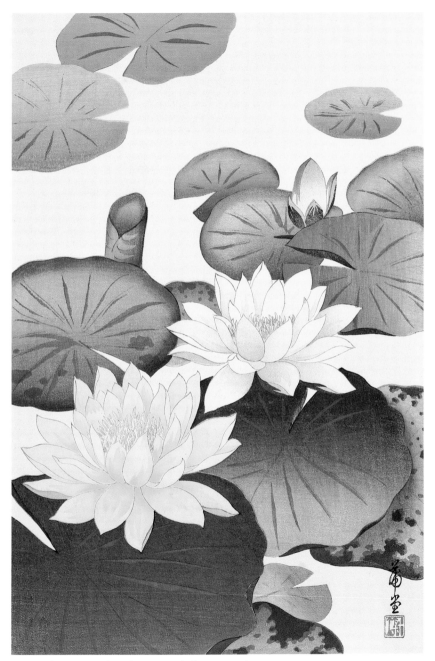

Water Lilies, c. 1930s | Nishimura Hodō (active 1930s)
Woodcut on paper | Senora Ryan Estate | AGGV 1991.052.007

野も山も

昼かとぞ首の

だるくこそ

no mo yama mo
hiru ka to zo kubi no
daruku koso

Plains and mountains both
clear as if noontime—gazing,
one's neck aches.

—Onitsura (1660–1738)

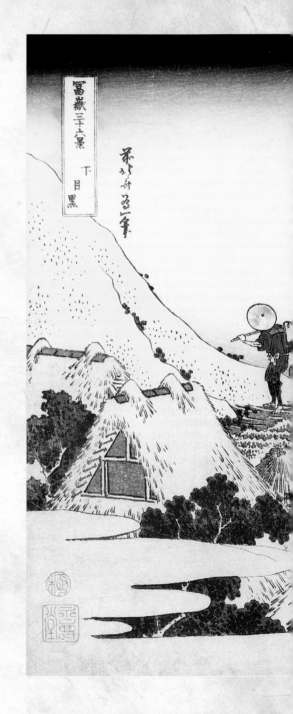

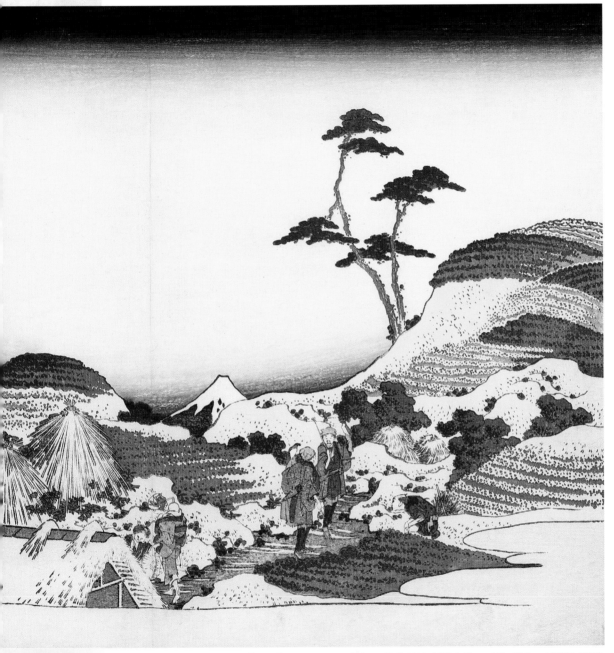

Fuji from Shimo Meguro, #25 from *Thirty-Six Views of Mount Fuji*, 1830–1833 | Katsushika Hokusai (1760–1849)
Woodcut on paper | Fred and Isabel Pollard Collection | AGGV 1963.075.001

動く葉も
なく恐ろしき
夏木立ち

ugoku ha mo
naku osoroshiki
natsu kodachi

Nothing is moving,
not even a single leaf—
awesome summer woods.

—Buson (1715–1783)

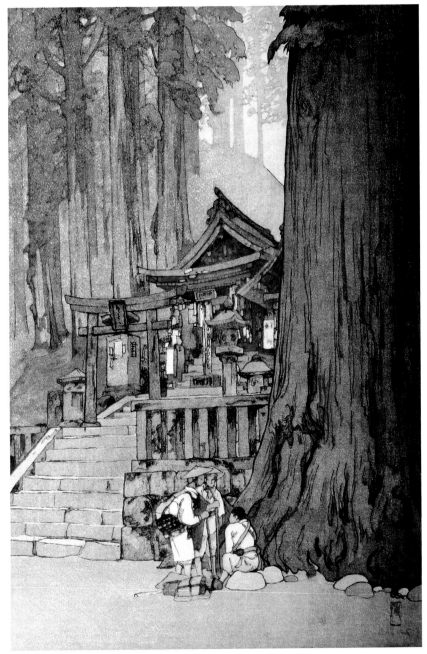

Misty Day in Nikkō, 1937 | Yoshida Hiroshi (1876–1950)
Woodcut on paper | Gift of Ralph W. Huenemann and Deirdre Roberts | AGGV 2008.012.001

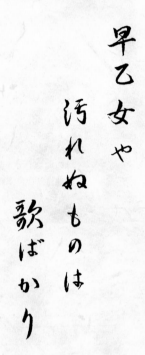

sa otome ya
yogorenu mono wa
uta ba kari

Women, planting rice—
the only thing not covered in mud—
their singing.

—Raizan (1653–1716)

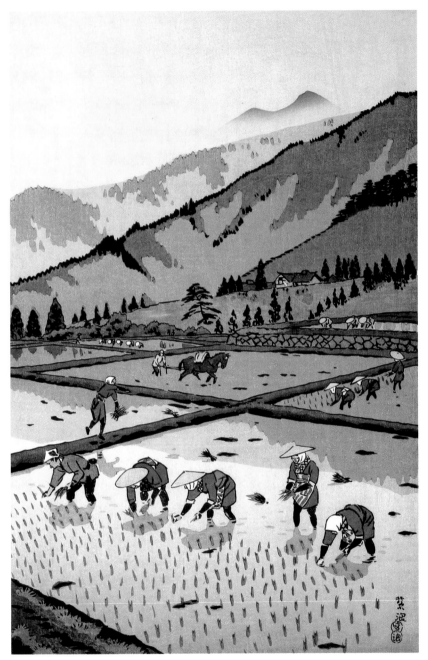

Rice Planting, 1953 | Kasamatsu Shirō (1898–1991)
Woodcut on paper | Given in memory of Mrs. Theo Wiggan by her Ikebana students and friends
AGGV 2008.002.001

古池や
蛙
飛び込む
水の音

furu ike ya
kawazu tobikomu
mizu no oto

Old pond,
and a frog dives in—
"Splash"!

—Bashō (1644–1694)

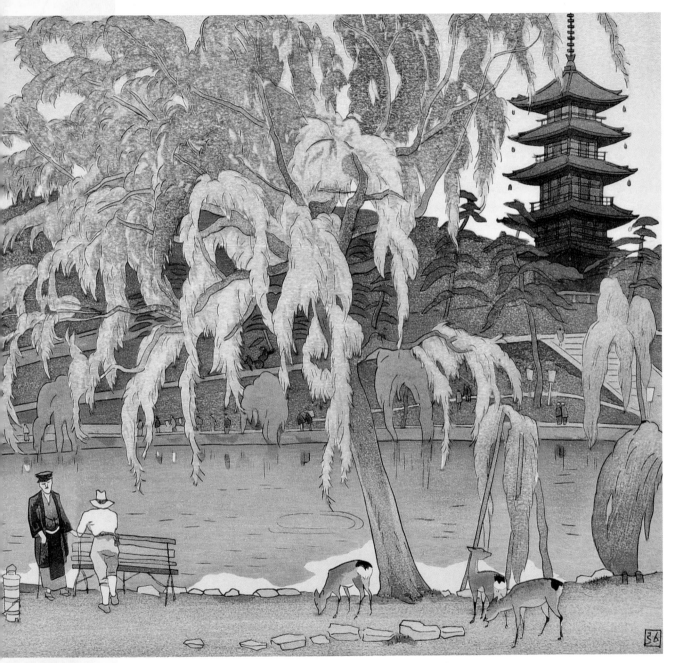

Willow Tree at Sarusawa Pond, 1935 | Nakazawa Hiromitsu (1874–1964)
Woodcut on paper | Gift of Capt. and Mrs. David W. Groos through the Asian Art Purchase Fund | AGGV 2008.030.016

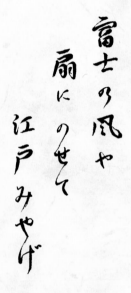

fuji no kaze ya
ōgi ni nosete
edo miyage

A breeze from Fuji
transported on a fan—an
Edo souvenir.

—Bashō (1644–1694)

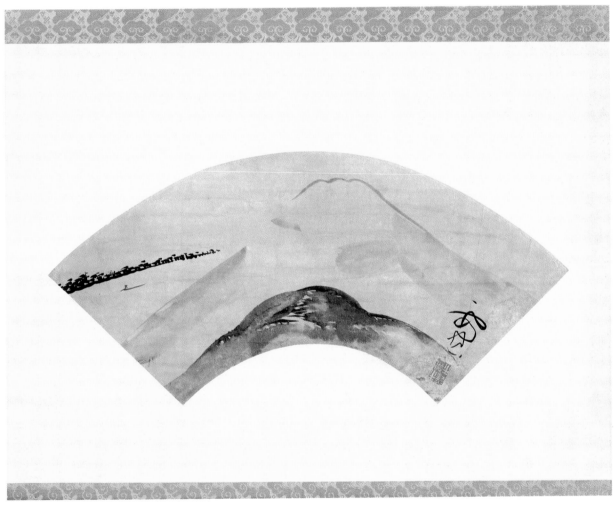

Mount Fuji, n.d. | Ike Taiga (1723–1776)
Ink on mica paper | Fred and Isabel Pollard Collection | AGGV 1970.105.001

 autumn

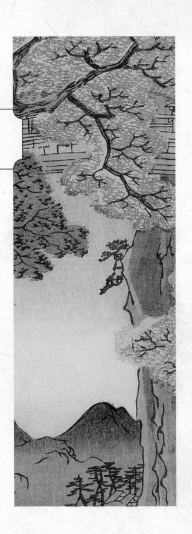

来るはずの
小夜しぐれ
ように来るなり

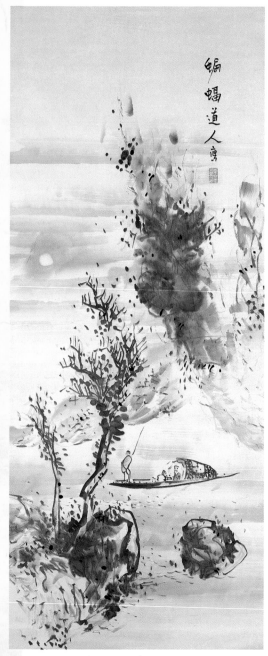

*kuru hazu no
yō ni kuru nari
sayo shigure*

As the summer's gone,
we are not surprised to see
autumn rain at night.

—Eiki (1823–1904)

Autumn Landscape, n.d. | Yokoi Kinkoku (1761–1832)
Ink on paper | Gift of Mrs. R. W. Finlayson | AGGV 1982.074.005

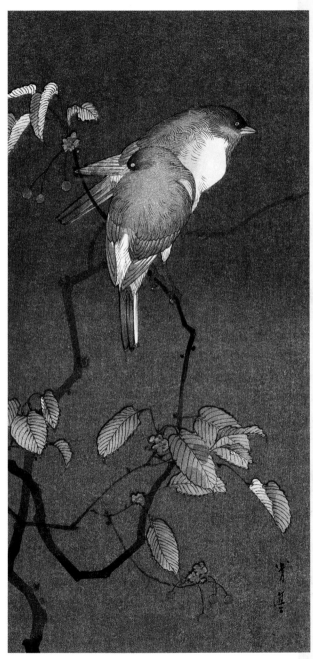

Blue Birds at Night, early 20th century | Watanabe Seitei (Shōtei) (1851–1918)
Woodcut on paper | Gift of Mr. and Mrs. William Hepler | AGGV 1992.044.017

夕闇に
実を探せるか
枝の鳥

*yūyami ni
mi o sagaseruka
eda no tori*

Birds on the branches
in the evening darkness—
can they find berries?

—Sasabune (contemporary)

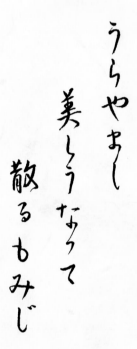

urayamashi
utsukushiu natte
chiru momiji

Coveted by all,
turning into such beauty—
the falling red leaves.

—Shikō (1664–1731)

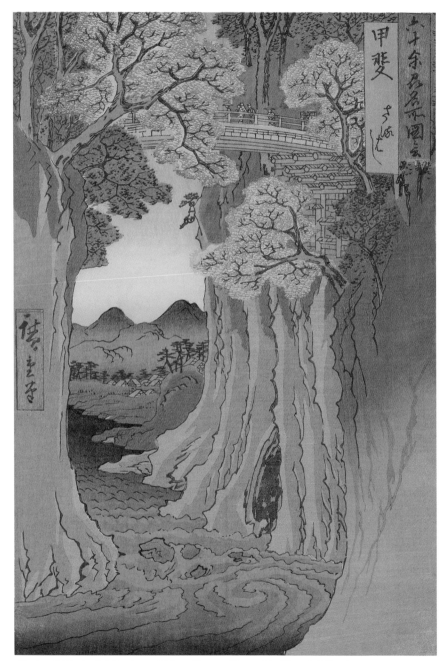

Monkey Bridge in Kai Province, #13 from *Famous Views of the Sixty-Odd Provinces*, 1853–1856
Andō Hiroshige (1797–1858) | Woodcut on paper | Gift of Theodore Lande | AGGV 1984.054.018

枯れ枝に
からすの止まりけり
秋の暮れ

kare eda ni
karasu no tomari keri
aki no kure

On a bare branch
crows have settled—
autumn sunset.

—Bashō (1644–1694)

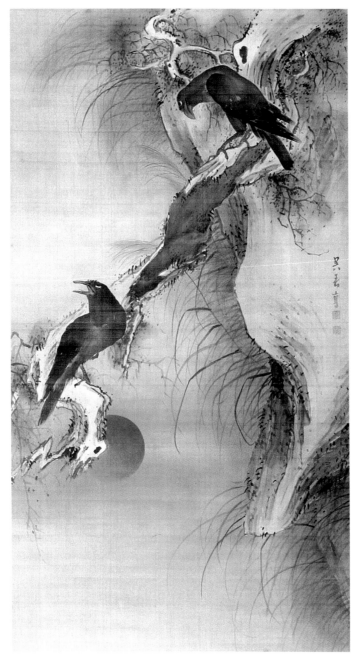

Two Crows in Sunset, n.d. | Matsumura Goshun (1752–1811)
Ink and colors on silk | Fred and Isabel Pollard Collection | AGGV 1967.144.001

遠山に
日のあたりたる
枯れ野かな

enzan ni
hi no ataritaru
kareno kana

On mountains far away
the sun is shining—
nearby, bleak fields.

—Kyoshi (1874–1959)

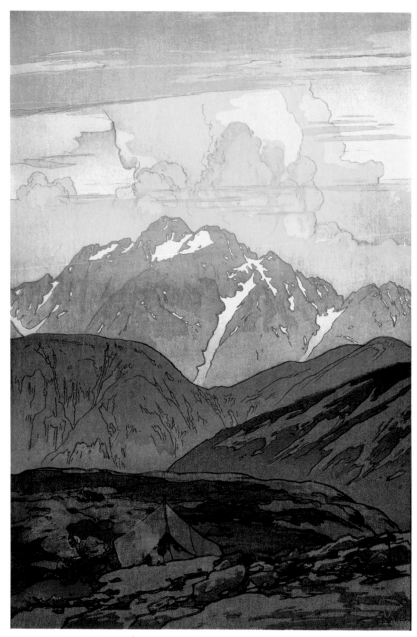

Tsurugizan, Morning, 1926 | Yoshida Hiroshi (1876–1950)
Woodcut on paper | Senora Ryan Estate | AGGV 1991.052.039

黄菊 白菊
ひと本は赤も
あらま欲し

ki giku shira giku
hito moto wa aka mo
aramahoshi

Yellow mums, white mums—
as for me, I crave a red
chrysanthemum too!

—Shiki (1867–1902)

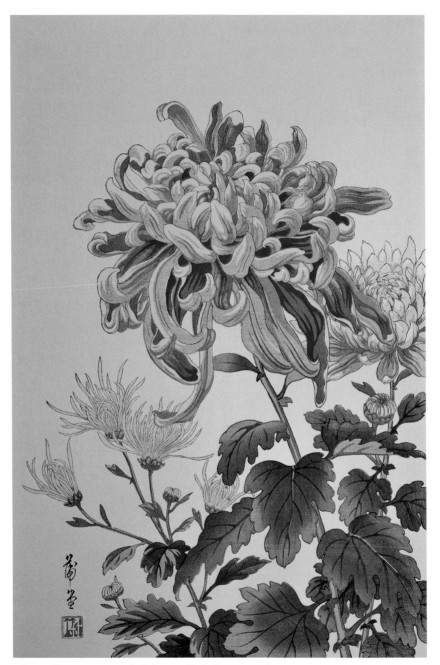

Chrysanthemum, c. 1930s | Nishimura Hodō (active 1930s)
Woodcut on paper | Senora Ryan Estate | AGGV 1991.052.004

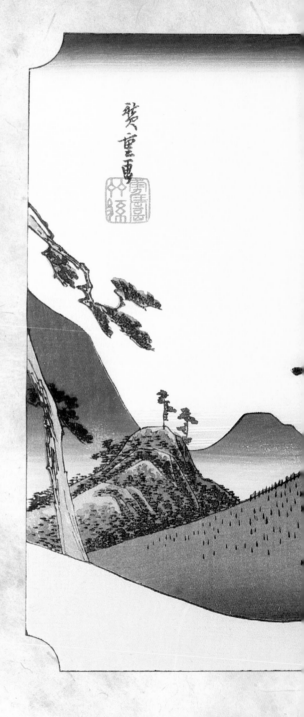

すゞ風や
虚空にみちて
松の声

suzu kaze ya
kokū ni michite
matsu no koe

How cool the breeze—
the empty sky is filled with
the sound of the pines.

—Onitsura (1660–1738)

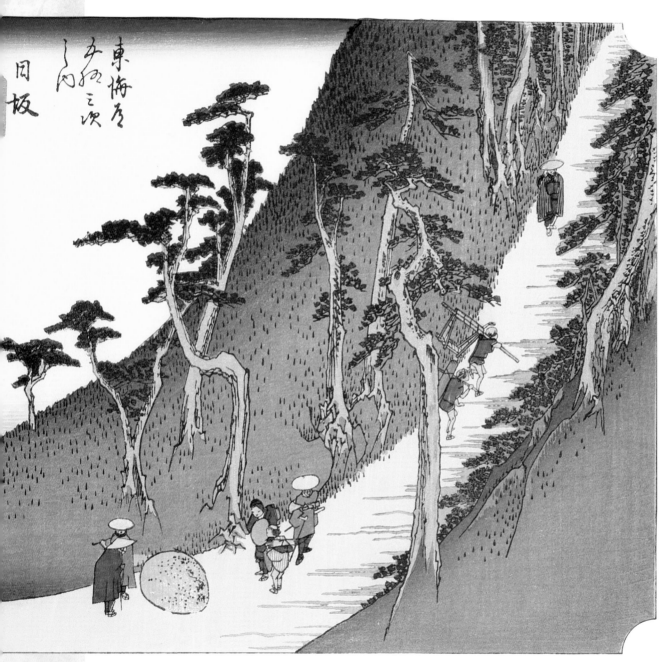

Nissaka, Sayo Mountain Pass (later reprint), #26 from *Fifty-Three Stages of the Tōkaidō*, 1833–1834 | Andō Hiroshige (1797–1858)
Woodcut on paper | Gift of Mr. and Mrs. J. L. Minnis | AGGV SC738

一行の
雁や端山に
月を印す

ichi gyō no
kari ya hayama ni
tsuki o in su

In calligraphic line
wild geese descend; at the foothills
the moon is the seal.

—Buson (1715–1783)

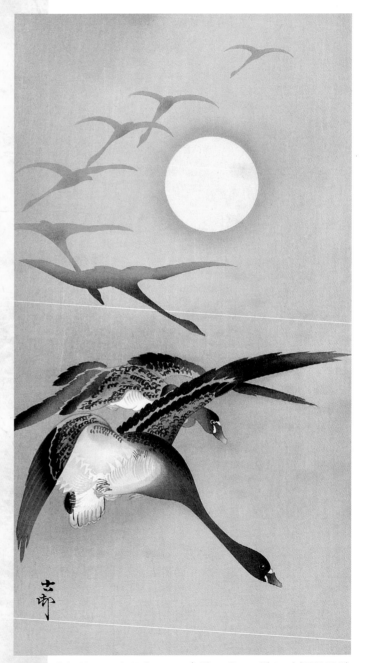

Geese and the Moon, early 20th century | Ohara Koson (Shōson) (1877–1945)
Woodcut on paper | Gift of Judith Patt | AGGV 2008.027.004

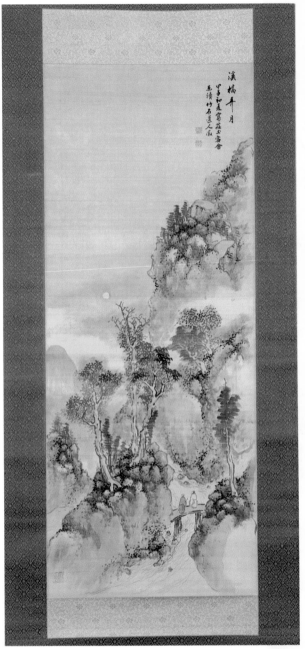

Moon Gazing from the Bridge, 1806 | Nagamachi Chikuseki (1747–1806)
Ink and light color on silk | Women's Committee Cultural Fund Purchase
AGGV 1977.110.001

月を松に
掛けたり外し
ても見たり

tsuki o matsu ni
kaketari hazushi
temo mitari

The moon on the pine—
hanging it, taking it off—
I keep on gazing.

—Hokushi (c. 1665–1718)

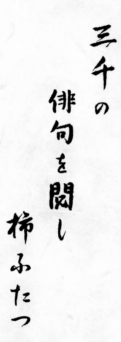

sanzen no
haiku o etsushi
kaki futatsu

Three thousand haiku
I have read through, and now—
two persimmons!

—Shiki (1867–1902)

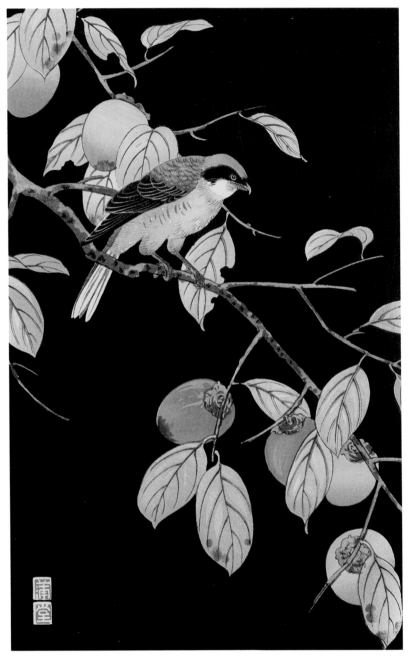

Sparrow Hawk on Persimmon Branch, c. 1930s | Nishimura Hodō (active 1930s)
Woodcut on paper | Gift of Mr. and Mrs. William Hepler | AGGV 1992.044.016

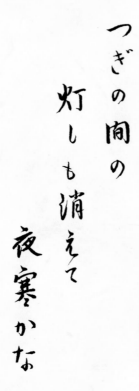

tsugi no ma no
tomoshi mo kiete
yo samu kana

The next room's light
also now goes out—
the night is cold.

—Shiki (1867–1902)

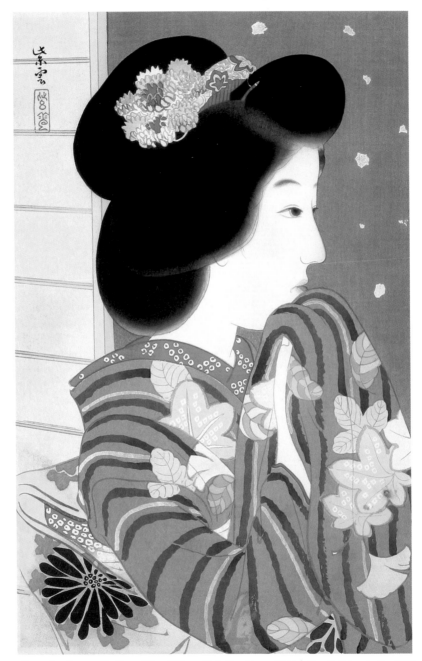

November, from collection of *New Ukiyo-e Style Beauties*, c. 1924 | Kondō Shiun (active 1910s–1930s)
Woodcut on paper | Given in memory of Mrs. Theo Wiggan by her Ikebana students and friends
AGGV 2007.036.003

 winter

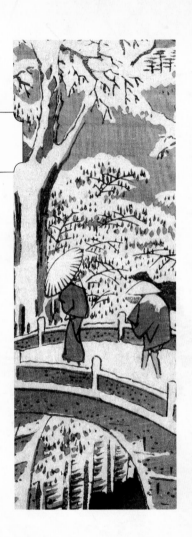

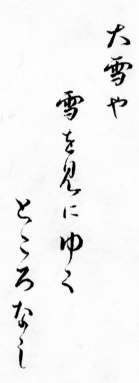

<div align="center">

ōyuki ya
yuki o mi ni yuku
tokoro nashi

So much snow—but
a place for snow viewing?
There's nowhere to go!

—Anonymous (late 18th century)

</div>

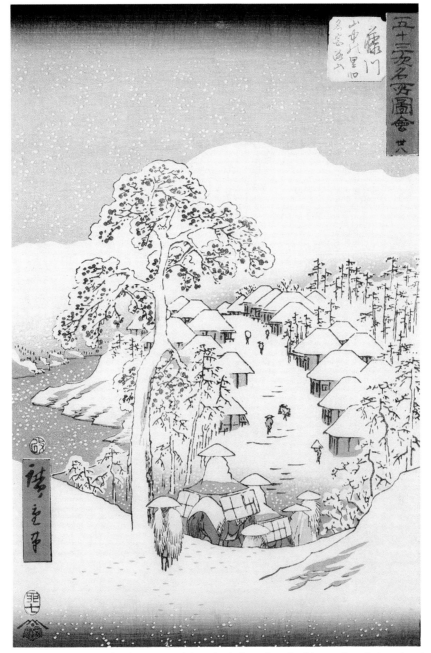

Fujikawa, #38 from *Fifty-Three Stages of the Tōkaidō (Upright Tōkaidō)*, 1855 | Andō Hiroshige (1797–1858)
Woodcut on paper | Gift of Theodore Lande | AGGV 1984.054.026

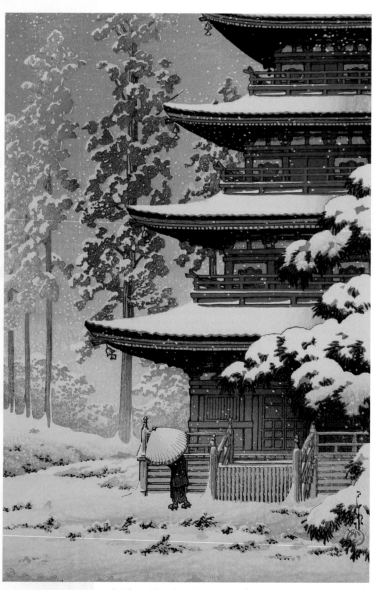

我が雪と
思えば軽し
笠のうえ

waga yuki to
omoeba karushi
kasa no ue

"My snow"—and thinking
that, it weighs almost nothing
atop my straw hat!

—Kikaku (1662–1707)

Saishoin Temple in Snow, 1936 | Kawase Hasui (1883–1957)
Woodcut on paper | Gift of Marnie Tunbridge | AGGV 2008.021.008

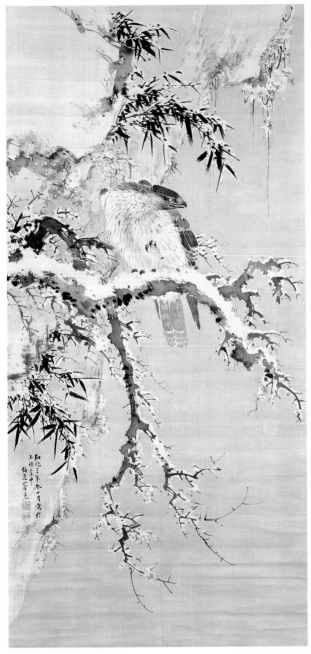

Hawk in Snow, 1846 | Yamamoto Baiitsu (1783–1856)
Ink on silk | Fred and Isabel Pollard Collection | AGGV 1967.143.001

天も地も
なし ただ雪の
降りしきる

ten mo chi mo
nashi tada yuki no
furishikiru

No sky and no ground—
only the snowflakes that
fall without ceasing.

—Hashin (1864–?)

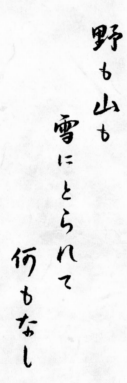

no mo yama mo
yuki ni torarete
nanimo nashi

Plains and mountains
all enveloped in the snow—
there is nothing else.

—Jōsō (1661–1704)

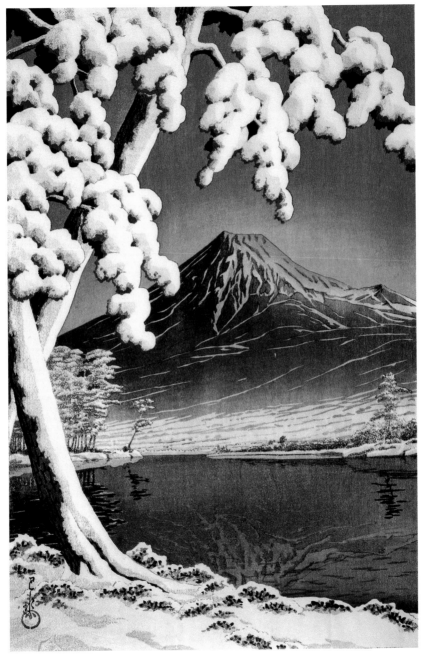

Mount Fuji Clear After Snow, Tagonoura, 1932 | Kawase Hasui (1883–1957)
Woodcut on paper | Gift of Elizabeth Marsters | AGGV 1994.013.021

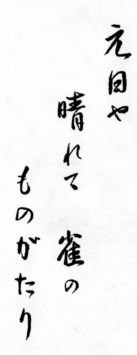

*ganjitsu ya
harete suzume no
monogatari*

New Year's Day—
the clouds are gone and sparrows
are telling each other tales.

—Ransetsu (1653–1708)

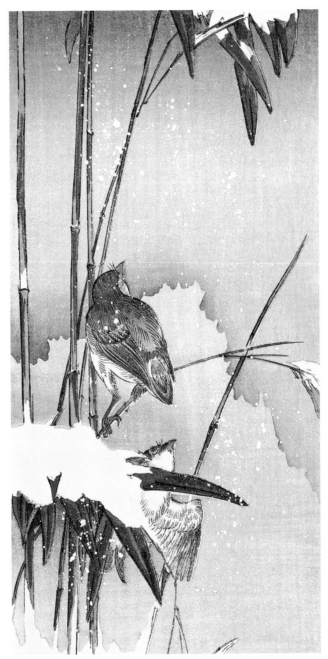

Sparrows and Bamboo, c. 1930s | Yoshimoto Gessō (1881–1936)
Woodcut on paper | Gift of Mr. and Mrs. William Hepler | AGGV 2007.012.002

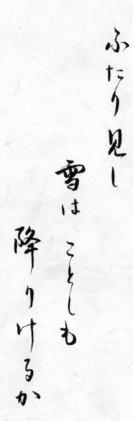

futari mishi
yuki wa kotoshi mo
furikeru ka

The snow we two once
viewed together—has it
fallen again this year?

—Bashō (1644–1694)

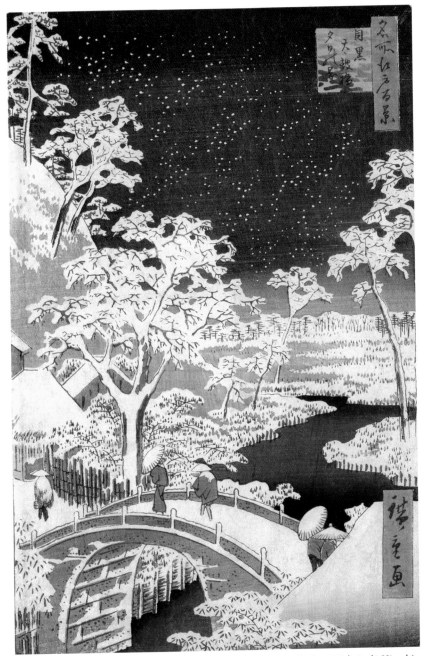

The Drum Bridge in Snow, #11 from *One Hundred Famous Views of Edo,* 1856 | Andō Hiroshige (1797–1858)
Woodcut on paper | Fred and Isabel Pollard Collection | AGGV 1965.038.001

これきりと
見えて
どっさり
春乃雪

kore kiri to
miete dossari
haru no yuki

It seems as if
this must be the end of it—
such a spring snow!

—Issa (1763–1828)

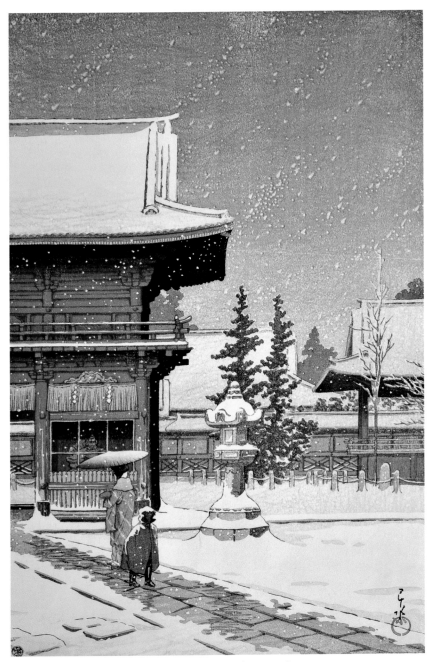

Snow at Nezugongen Shrine, c. 1933 | Kawase Hasui (1883–1957)
Woodcut on paper | Gift of Marnie Tunbridge | AGGV 2008.021.007

about the authors

JUDITH PATT—now retired from teaching Japanese and Southeast Asian art history at the University of Victoria, British Columbia—received a Bachelor of Architecture degree from Stanford University and M.A. and Ph.D. degrees from the University of California, Berkeley. She coauthored, with Barry Till and Michiko Warkentyne, *The Kimono of the Geisha-Diva Ichimaru,* also published by Pomegranate.

MICHIKO WARKENTYNE (née Sasaoka) was born and raised in Japan, where she studied classical Japanese as well as English. After graduating from college in Tokyo, she came to Canada. She received her B.A. in Honors English Language and Literature from the University of Western Ontario and then traveled around the globe twice. Finally, she settled down with her family in Victoria, Canada, where she taught Japanese at the University of Victoria for many years.

BARRY TILL is the curator of Asian art at the Art Gallery of Greater Victoria, British Columbia, and the author of *Shin Hanga: The New Print Movement of Japan, Japan Awakens: Woodblock Prints of the Meiji Period (1868–1912),* and *The 47 Ronin: A Story of Samurai Loyalty and Courage,* all published by Pomegranate.